Thin slices
of anxiety

First published in the United States of America in 2016
by Chronicle Books LLC.

Originally published in Canada in 2014 by Éditions Somme Toute.

Library of Congress Cataloging-in-Publication data available.

ISBN: 978-1-4521-4579-2

Manufactured in China

MIX
Paper from
responsible sources
FSC
www.fsc.org
FSC™ C008047

10 9 8 7 6 5 4 3 2 1

Éditions Somme Toute
4609 d'Iberville #300
Montréal, Québec
H2H 2L9
www.editionssommetoute.com

Chronicle Books LLC
680 Second Street
San Francisco, CA 94107

www.chroniclebooks.com

Thin slices of anxiety

Observations and Advice to Ease a Worried Mind

CATHERINE LEPAGE

CHRONICLE BOOKS

SAN FRANCISCO

Are you
ANXIOUS?

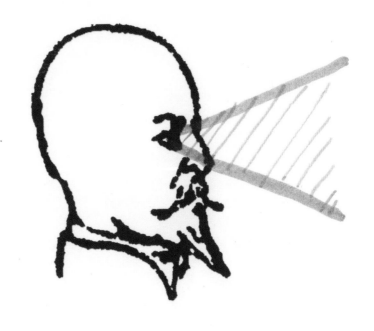

FIELD OF VISION FOR

A <u>normal</u> PERSON

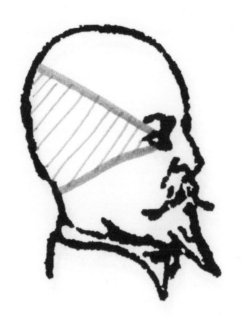

FIELD OF VISION FOR

AN anxious PERSON

I
AM.

It's cyclic,
it comes
and goes.

When it
happens,
I FREEZE.

EVERYTHING

becomes

BLURRY.

Making

a simple

DECISION

becomes

IMPOSSIBLE.

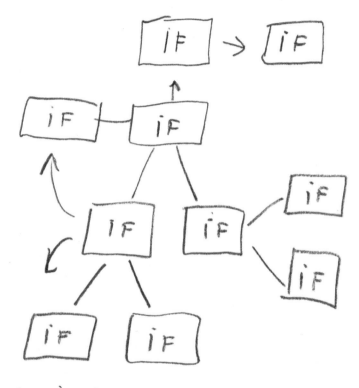

PERIODIC TABLE OF THE
ELEMENTS OF RESPONSE

I **ALWAYS**

SIMULTANEOUSLY
SEE TWO SIDES
OF the SAME
COIN.

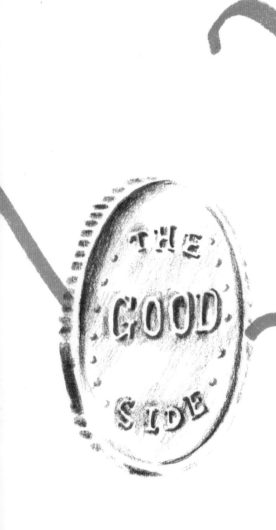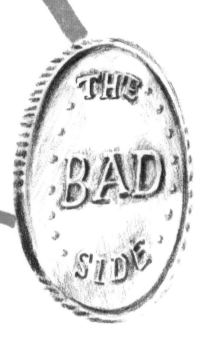

AND sometimes,
i find

EVEN

MORE

sides!

tHat's how it is.
WHEN ANXiETY
STRiKES, I'M
completely
overcome by it.

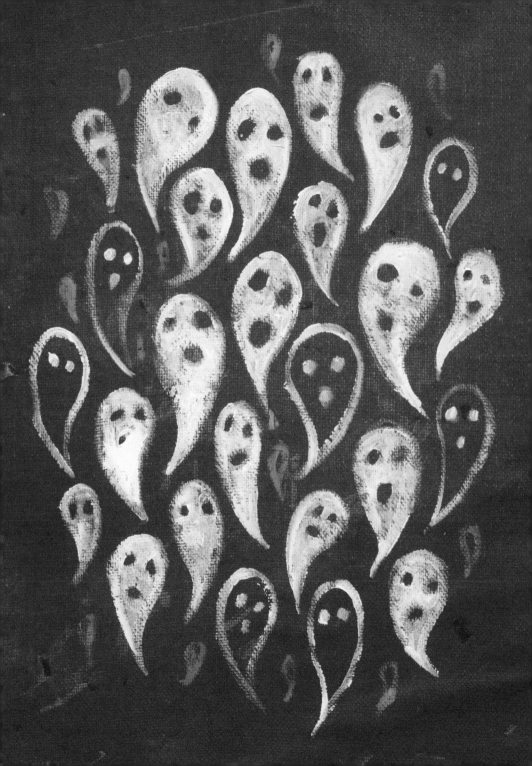

it's

UNCONTROLLABLE.

and even if
it's something I'VE
KNOWN for a long time,
I still don't KNOW
HOW
to face it.

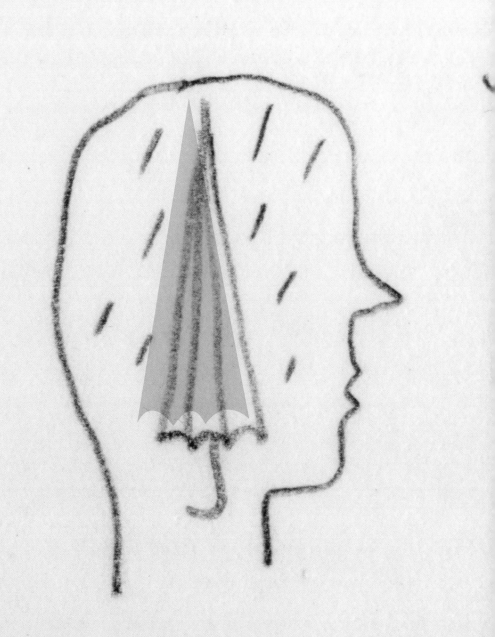

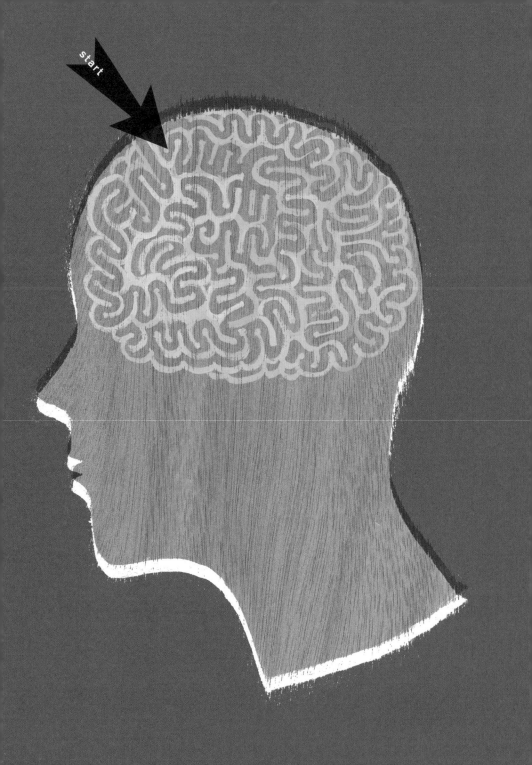

start

However,
I've been ABLE
to iDENTiFY iTS

PATHS.

CHAPTER 1

The 4 habits that trigger anxiety

#1

accumulating

TOO MUCH

fatigue

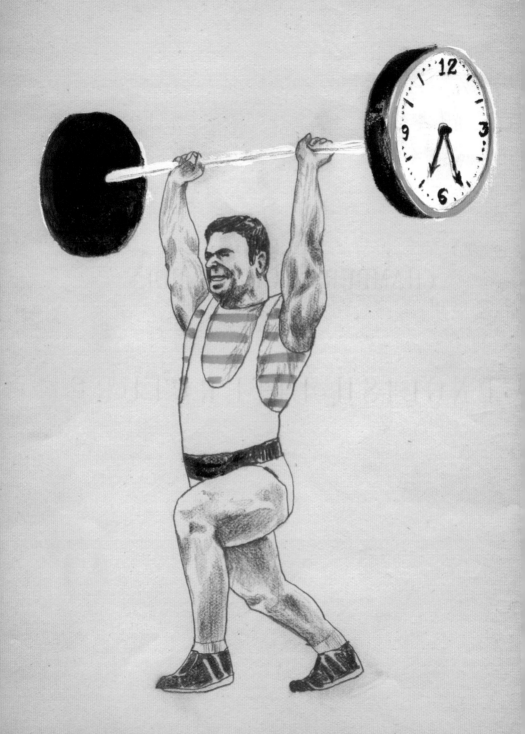

#2

Repressing *your* emotions

3

Setting

goals

TOO

high

4

Collecting Responsibilities

Since I KNOW

THE CAUSES of

MY ANXIETY,

WHY

DO I KEEP
REPEATING THESE
UNHEALTHY
BEHAVIORS?

CHAPTER 2

The appeal
of
risk

It's not my fault,
I LOVE to perform
AND SHOW OFF.

AND when
I'm motivated,
I DON'T MANAGE
my energy well.

My inner voice
tells me CAREFUL!

IT'S DANGEROUS.

THRILLED

by my projects,

I TEND TO TAKE it

a little

TOO FAR.

I guess
I like to
PLAY with

FIRE.

It always
ends up
the SAME.

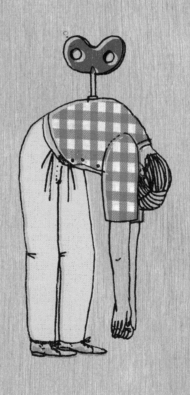

AND I HAVE TO
FACE MY BIGGEST
FEAR:
EMPTI
NESS.

afterwards,

I spend days
FLOUNDERING in
my DISCOMFORT.

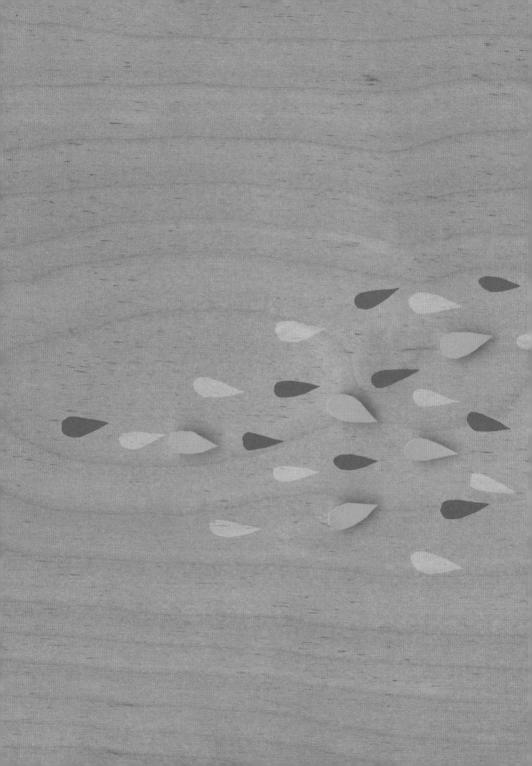

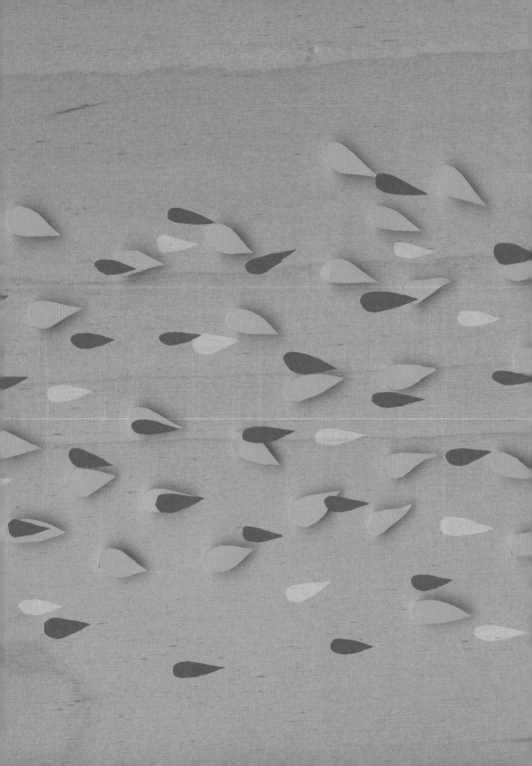

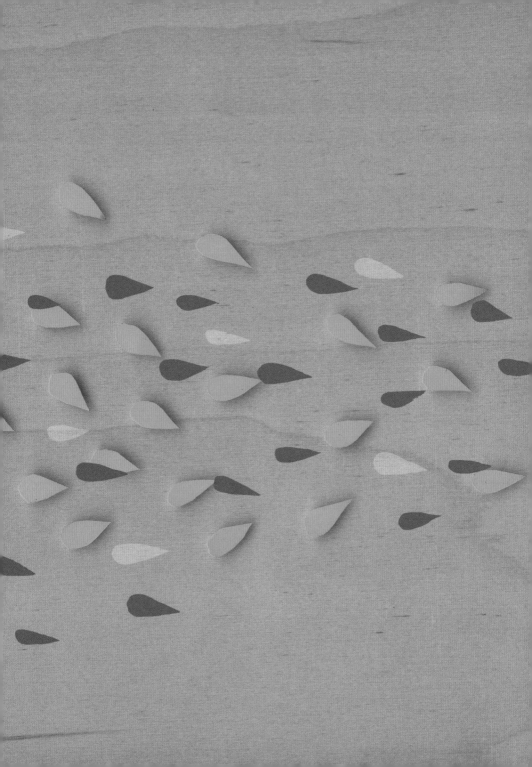

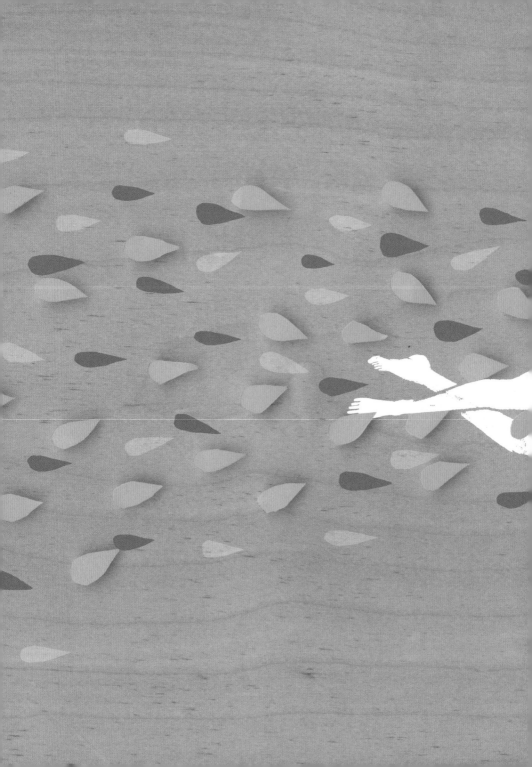

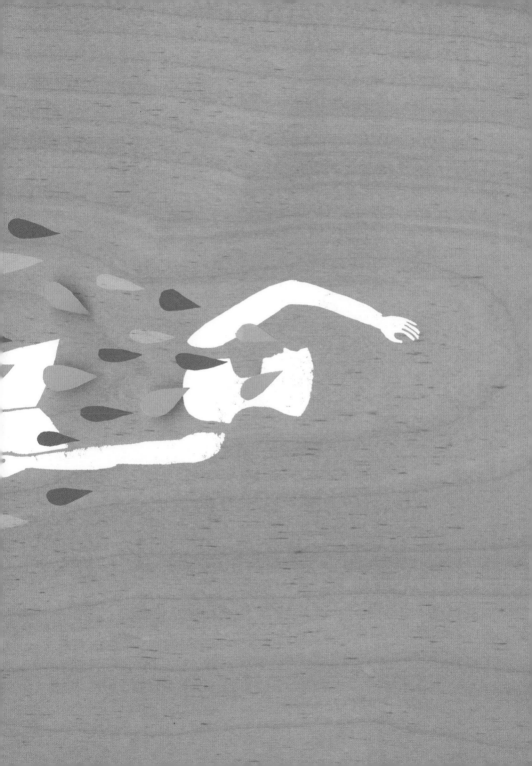

I struggle to
get out of it,
BUT I only
TREAD water.

Maybe I don't
FOCUS my EFFORTS
in the right
PLACE.

EASINESS

UNEASINESS

In those MOMENTS,
I'm afraid of FALLING
back into
DEPRESSION.

TRY not to ALWAYS expect the WORST

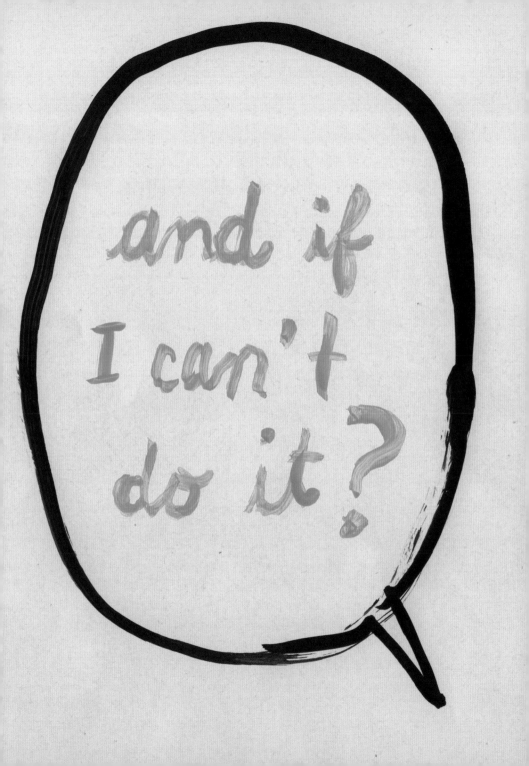

CHAPTER 3

③ cheesy quotes to remember

01

Open
your
heart

02

If your ego
PREVENTS YOU FROM EVOLVING,
REMOVE ITS E.

#03

SOMETIMES, TAKING A

step back

IS THE BEST WAY TO

move forward

CHAPTER 4

OK,

I admit...

It's a bit
my FAULT
as well.

I live through
other PEOPLE'S EYES.
I HAVE A
FEAR of
JUDGMENT.

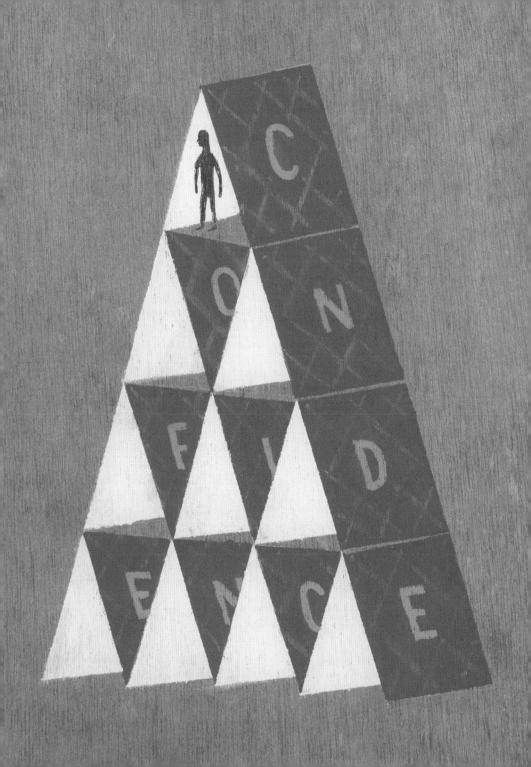

so I TRY
to act like
EVERYONE ELSE.

BUT I *feel*
OUT OF PLACE.

By the way, WHAT'S MY PLACE?

I've spent so
many years
repressing my
feelings that
I've lost touch
with my emotions,

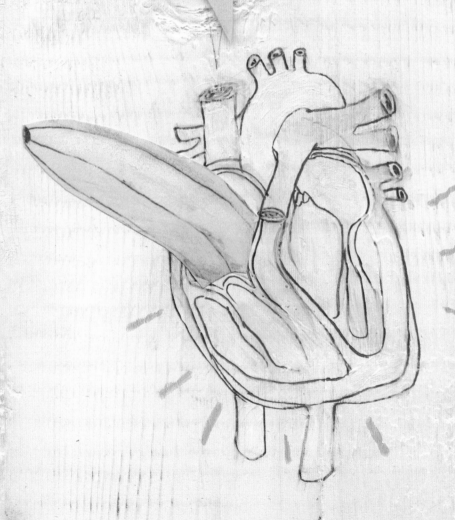

I would like to CHANGE, BUT I DON'T KNOW HOW.

And so I feel
GUILTY for NOT
BEING WELL, me,
the privileged one
who has EVERYTHING
in life. HEALTH,
LOVE, everything.

I'M
NEVER
SATISFIED.

Fin

ALLY,

I'm only
human.

Thinly sliced and illustrated,
EMOTIONS ARE
MUCH
- - - - - - - -
easier to digest.